CLASSIC COLORING

Alice in Wonderland

55 Removable Coloring Plates

ABRAMS NOTERIE, NEW YORK

Designer: Hana Anouk Nakamura

Illustrator: John Tenniel

ISBN: 978-1-4197-2206-6

Copyright © 2016 Abrams Noterie

A note on type: the quote pages in this book are inspired by the original manuscript "Alice's Adventures Under Ground," which Lewis Carroll personally lettered and illustrated. We hope you enjoy coloring them.

Published in 2016 by Abrams Noterie, an imprint of ABRAMS. All rights reserved. No portion of this book may be reproduced, stored in a retrieval system, or transmitted in any form or by any means, mechanical, electronic, photocopying, recording, or otherwise, without written permission from the publisher.

Printed and bound in China
10 9 8 7 6 5 4 3 2

Abrams Noterie products are available at special discounts when purchased in quantity for premiums and promotions as well as fundraising or educational use. Special editions can also be created to specification. For details, contact specialsales@abramsbooks.com or the address below.

ABRAMS
THE ART OF BOOKS SINCE 1949
115 West 18th Street
New York, NY 10011
www.abramsbooks.com

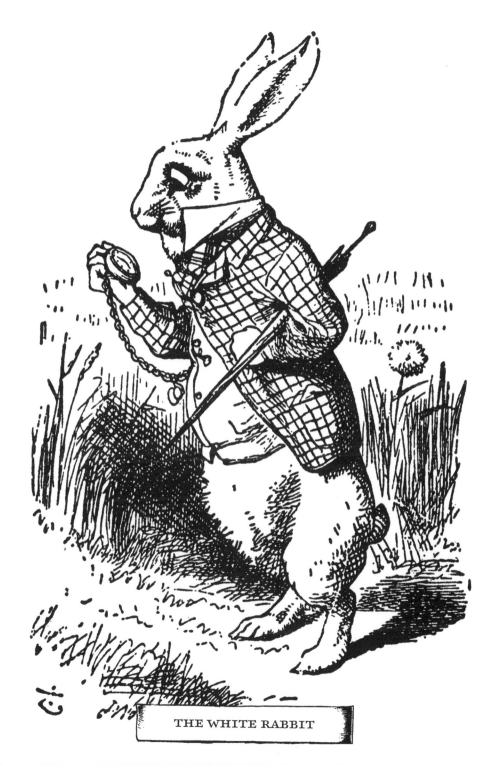

THE WHITE RABBIT

\mathcal{A}lice started to her feet, for it flashed across her mind that she had never before seen a rabbit with either a waistcoat-pocket, or a watch to take out of it, and, burning with curiosity, she ran across the field after it, and fortunately was just in time to see it pop down a large rabbit-hole under the hedge.

Alice's Adventures in Wonderland

Oh my ears and whiskers!

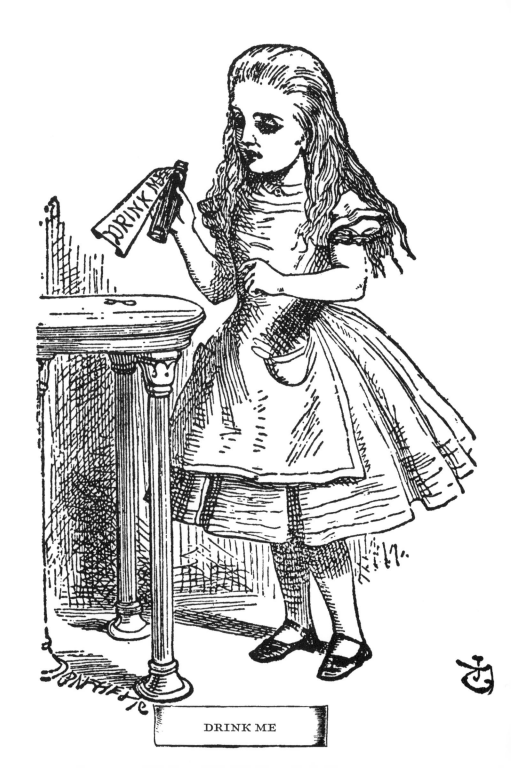

DRINK ME

*T*his time she found a little bottle on it ("which certainly was not here before," said Alice), and tied around the neck of the bottle as a paper label, with the words "DRINK ME" beautifully printed on it in large letters.

Alice's Adventures in Wonderland

Curiouser and curiouser

GOOD-BYE, FEET!

"*N*ow I'm opening out like the largest telescope
that ever was! Good-bye, feet!" (for when she looked
down at her feet, they seemed to be almost out of sight,
they were getting so far off).

Alice's Adventures in Wonderland

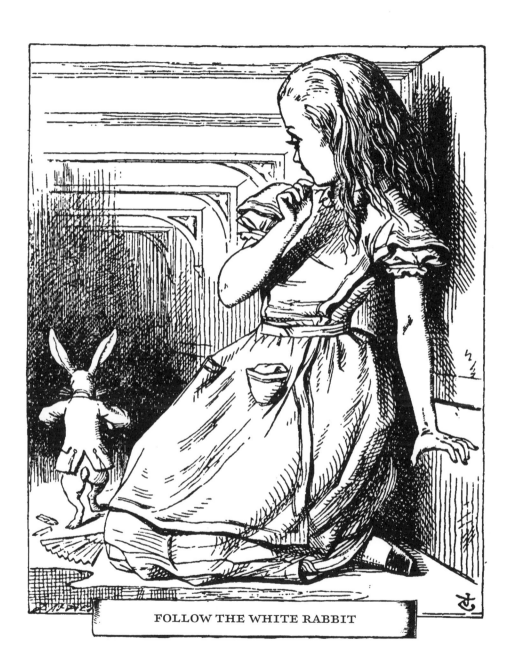

FOLLOW THE WHITE RABBIT

*A*lice felt so desperate that she was ready to ask help of any one; so, when the Rabbit came near her, she began, in a low, timid voice, "If you please, sir—" The Rabbit started violently, dropped the white kid gloves and the fan, and scurried away into the darkness as hard as he could go.

Alice's Adventures in Wonderland

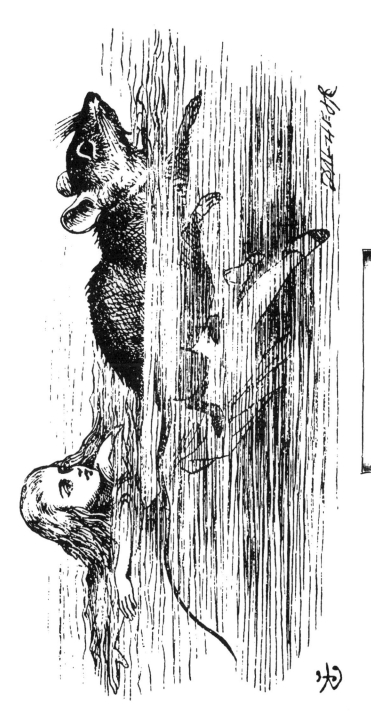

A POOL OF TEARS

"*O*h dear!" cried Alice in a sorrowful tone. "I'm afraid I've offended it again!" For the Mouse was swimming away from her as hard as it could go, and making quite a commotion in the pool as it went.

Alice's Adventures in Wonderland

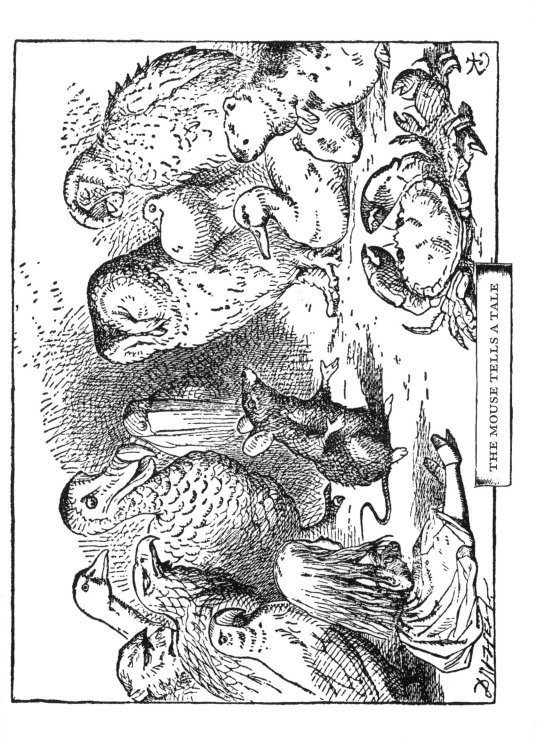

THE MOUSE TELLS A TALE

*T*hey were indeed a queer-looking party that assembled on the bank—the birds with draggled feathers, the animals with their fur clinging close to them, and all dripping wet, cross, and uncomfortable.

Alice's Adventures in Wonderland

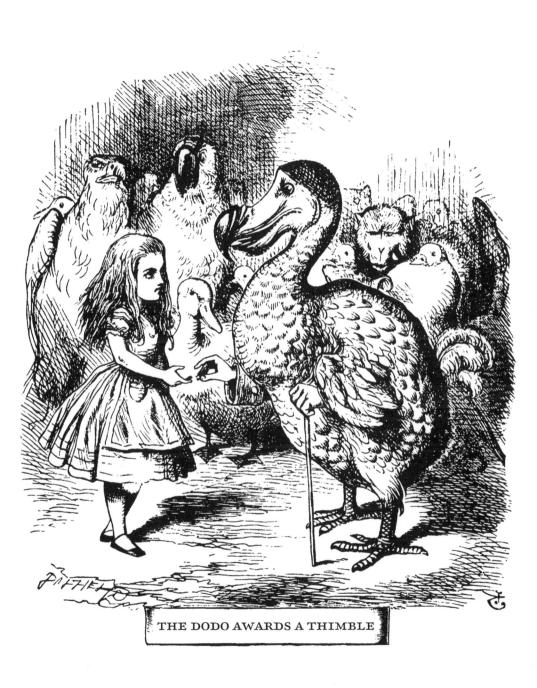

THE DODO AWARDS A THIMBLE

*T*hen they all crowded round her once more, while the Dodo solemnly presented the thimble, saying, "We beg your acceptance of this elegant thimble"; and, when it had finished this short speech, they all cheered.

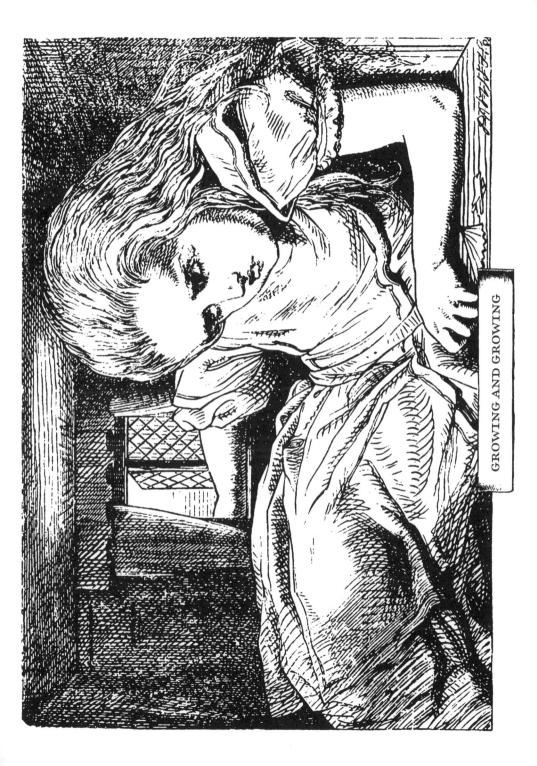

GROWING AND GROWING

*S*he went on growing, and growing, and very soon had to kneel down on the floor: in another minute there was not even room for this, and she tried the effect of lying down with one elbow against the door, and the other arm curled round her head. Still she went on growing, and, as a last resource, she put one arm out of the window and one foot up the chimney, and said to herself, "Now I can do no more, whatever happens. What *will* become of me?"

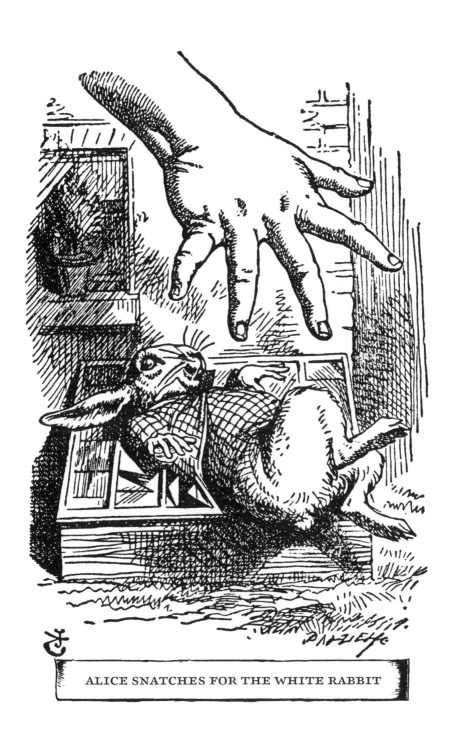

ALICE SNATCHES FOR THE WHITE RABBIT

*A*fter waiting till she fancied she heard the Rabbit just under the window, she suddenly spread out her hand, and made a snatch in the air. She did not get hold of anything, but she heard a little shriek and a fall, and a crash of broken glass, from which she concluded that it was just possible it had fallen into a cucumber-frame, or something of the sort.

Alice's Adventures in Wonderland

She generally gave herself very good advice (though she seldom followed it).

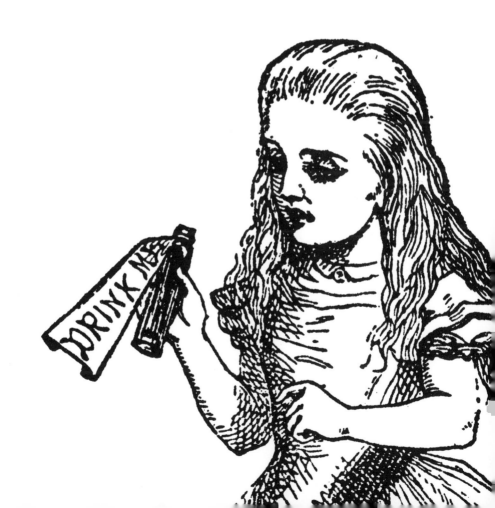

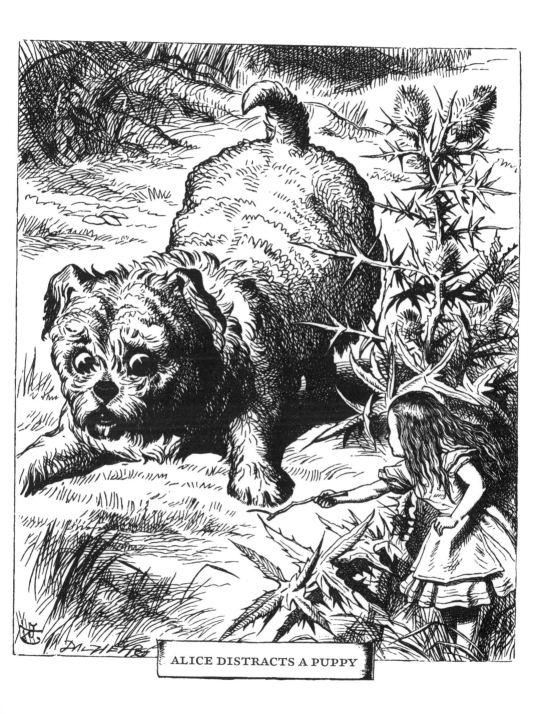

ALICE DISTRACTS A PUPPY

*S*he picked up a little bit of stick, and held it out
to the puppy; whereupon the puppy jumped into the air
off all its feet at once, with a yelp of delight, and rushed
at the stick, and made believe to worry it; then Alice
dodged behind a great thistle, to keep herself from being run
over; and the moment she appeared on the other side, the
puppy made another rush at the stick, and tumbled head
over heels in its hurry to get hold of it.

Alice's Adventures in Wonderland

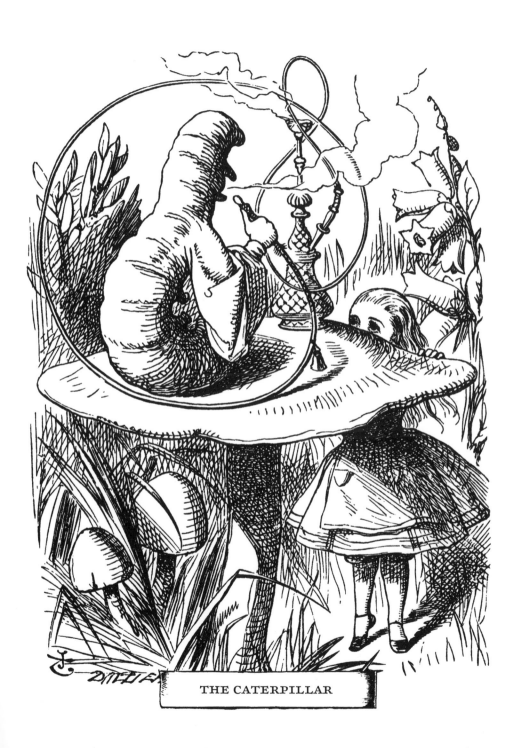

THE CATERPILLAR

*S*he stretched herself up on tiptoe, and peeped over the edge of the mushroom, and her eyes immediately met those of a large caterpillar, that was sitting on the top with its arms folded, quietly smoking a long hookah, and taking not the smallest notice of her or anything else....

"Who are *you?*" said the Caterpillar.

Alice's Adventures in Wonderland

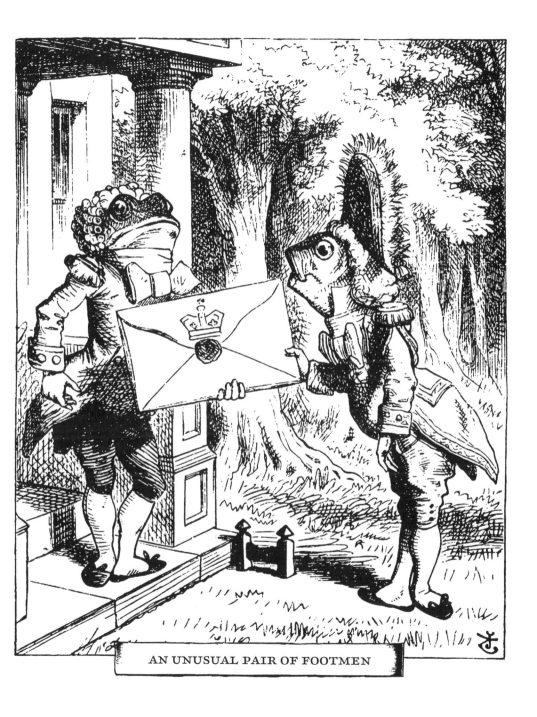

AN UNUSUAL PAIR OF FOOTMEN

Suddenly a footman in livery came running out of the wood—
(she considered him to be a footman because he was in livery:
otherwise, judging by his face only, she would have called him
a fish)—and rapped loudly at the door with his knuckles.
It was opened by another footman in livery, with a round face,
and large eyes like a frog; and both footmen, Alice noticed, had
powdered hair that curled all over their heads. She felt very
curious to know what it was all about, and crept a little way out
of the wood to listen.

Alice's Adventures in Wonderland

ALICE MEETS THE DUCHESS

*T*he door led right into a large kitchen, which was full of smoke from one end to the other: the Duchess was sitting on a three-legged stool in the middle, nursing a baby; the cook was leaning over the fire, stirring a large cauldron which seemed to be full of soup.

"There's certainly too much pepper in that soup!" Alice said to herself, as well as she could for sneezing.

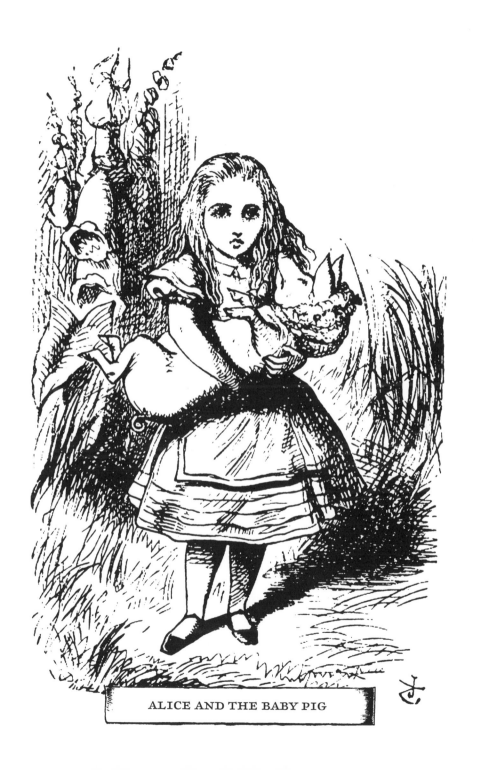

ALICE AND THE BABY PIG

"*I*f you're going to turn into a pig, my dear," said Alice, seriously, "I'll have nothing more to do with you."

Alice's Adventures in Wonderland

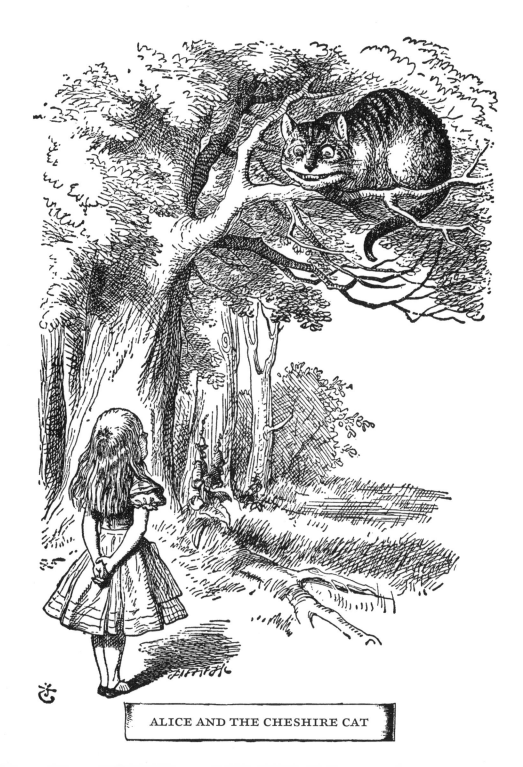

ALICE AND THE CHESHIRE CAT

*S*he was a little startled by seeing the Cheshire Cat sitting on a bough of a tree a few yards off.

The Cat only grinned when it saw Alice. It looked good-natured, she thought: still it had *very* long claws and a great many teeth, so she felt that it ought to be treated with respect.

Alice's Adventures in Wonderland

We're all mad here.

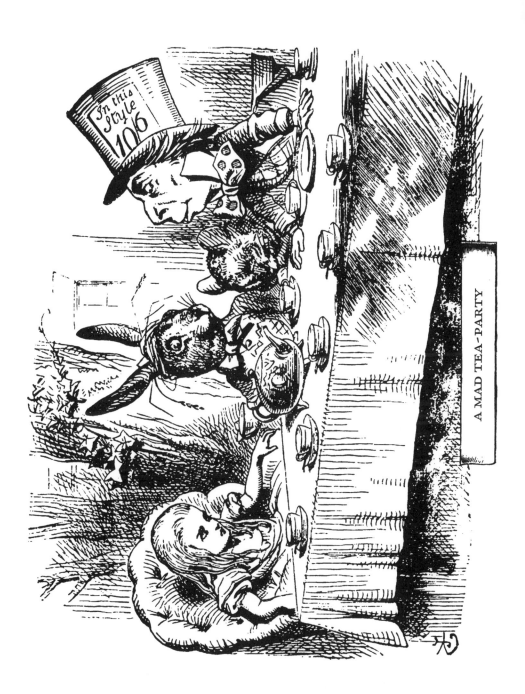

A MAD TEA-PARTY

*T*here was a table set out under a tree in front of the house, and the March Hare and the Hatter were having tea at it: a Dormouse was sitting between them, fast asleep, and the other two were using it as a cushion, resting their elbows on it, and talking over its head. "Very uncomfortable for the Dormouse," thought Alice; "only as it's asleep, I suppose it doesn't mind."

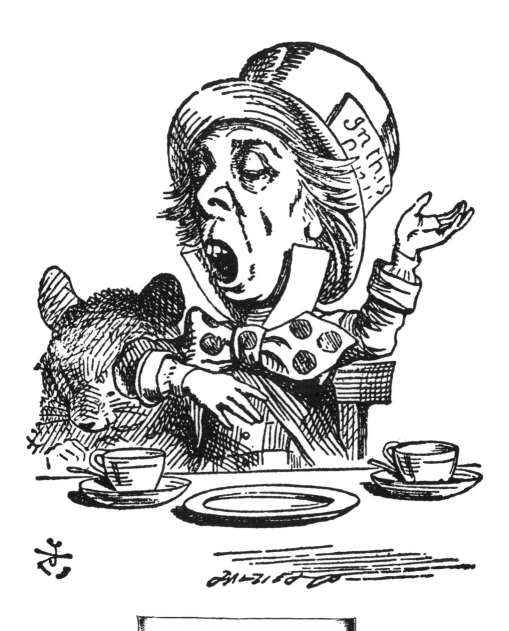

THE MAD HATTER

"*It* was at the great concert given by the Queen of Hearts,
and I had to sing

'Twinkle, twinkle, little bat!
How I wonder what you're at!'

You know the song, perhaps?"
"I've heard something like it," said Alice.
"It goes on, you know," the Hatter continued, "in this way:—

'Up above the world you fly,
Like a tea-tray in the sky.'"

Alice's Adventures in Wonderland

Twinkle,
twinkle,
little bat!
How I wonder
where you're at!

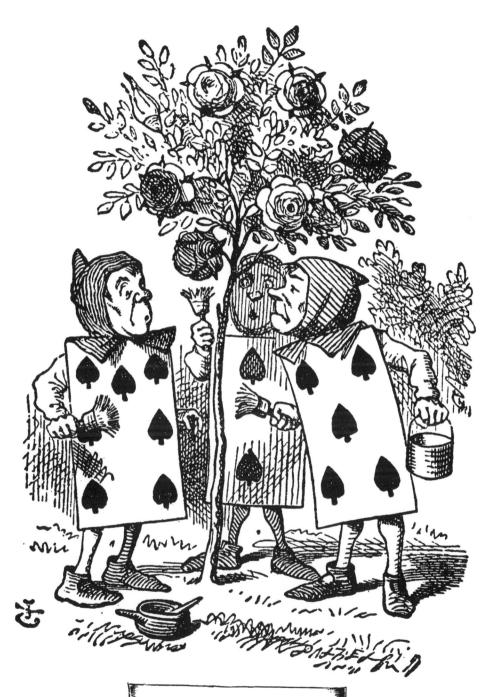

PAINTING THE ROSES RED

A large rose-tree stood near the entrance of the garden: the roses growing on it were white, but there were three gardeners at it, busily painting them red.

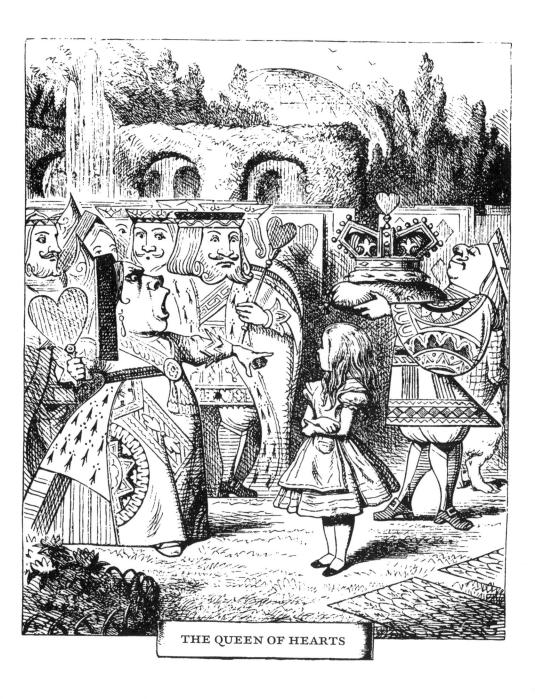

THE QUEEN OF HEARTS

*T*he Queen turned crimson with fury, and,
after glaring at her for a moment like a wild beast,
screamed "Off with her head! Off—"

"Nonsense!" said Alice, very loudly and decidedly,
and the Queen was silent.

Alice's Adventures in Wonderland

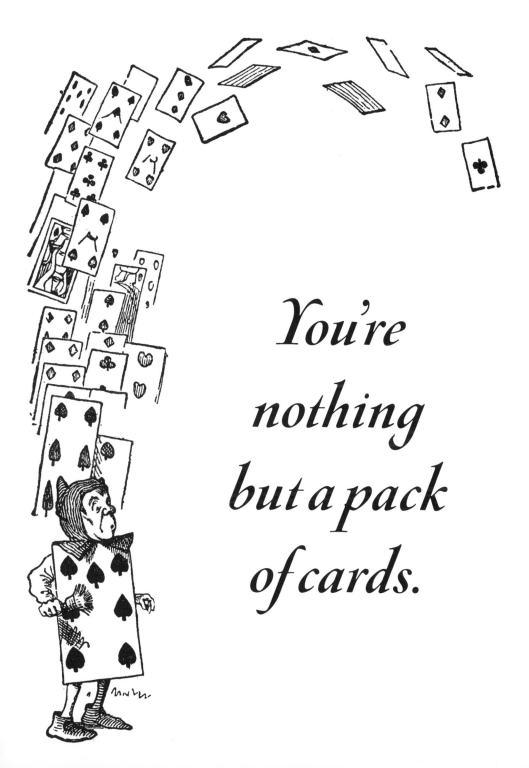

You're nothing but a pack of cards.

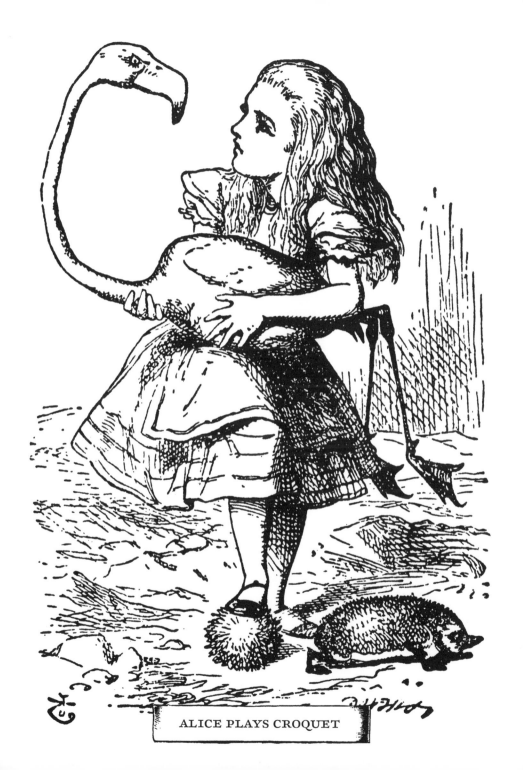

ALICE PLAYS CROQUET

*A*lice thought she had never seen such a curious croquet-ground in her life; it was all ridges and furrows; the balls were live hedgehogs, the mallets live flamingoes, and the soldiers had to double themselves up and stand on their hands and feet, to make the arches.

Alice's Adventures in Wonderland

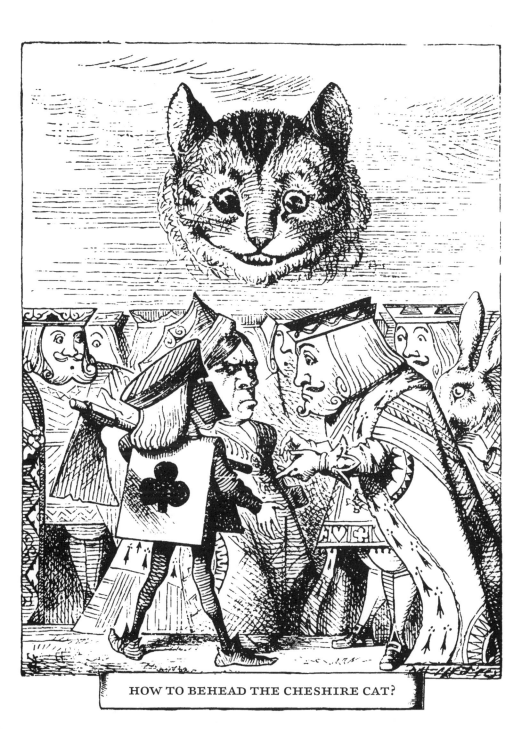

HOW TO BEHEAD THE CHESHIRE CAT?

*T*he executioner's argument was, that you couldn't cut off a head unless there was a body to cut it off from: that he had never had to do such a thing before, and he wasn't going to begin at *his* time of life.

The King's argument was, that anything that had a head could be beheaded, and that you weren't to talk nonsense.

The Queen's argument was, that if something wasn't done about it in less than no time she'd have everybody executed, all round.

Alice's Adventures in Wonderland

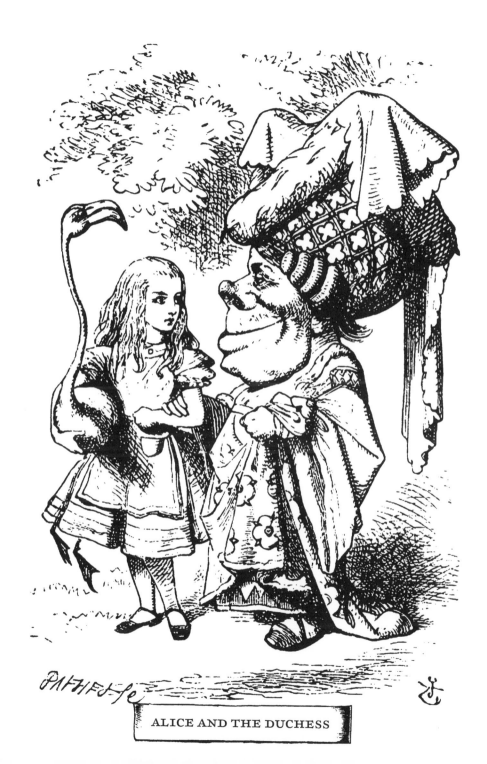

ALICE AND THE DUCHESS

"*I* dare say you're wondering why I don't put my arm round your waist," the Duchess said after a pause: "the reason is, that I'm doubtful about the temper of your flamingo. Shall I try the experiment?"

"He might bite," Alice cautiously replied, not feeling at all anxious to have the experiment tried.

Alice's Adventures in Wonderland

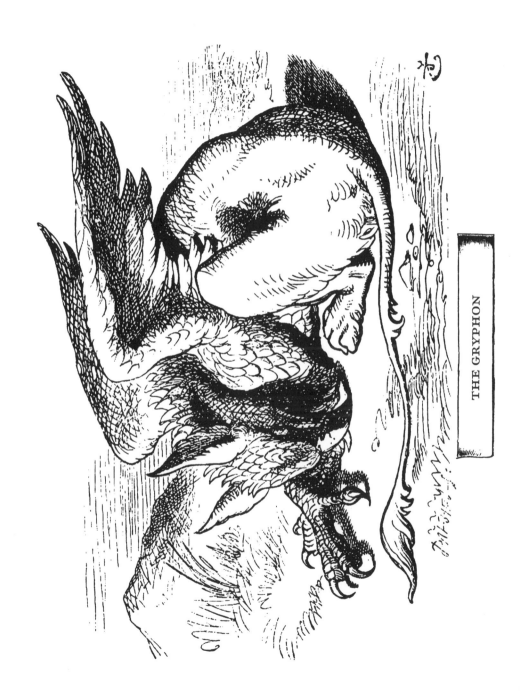

THE GRYPHON

*T*hey very soon came upon a Gryphon, lying fast asleep in the sun.
(If you don't know what a Gryphon is, look at the picture.)

Alice's Adventures in Wonderland

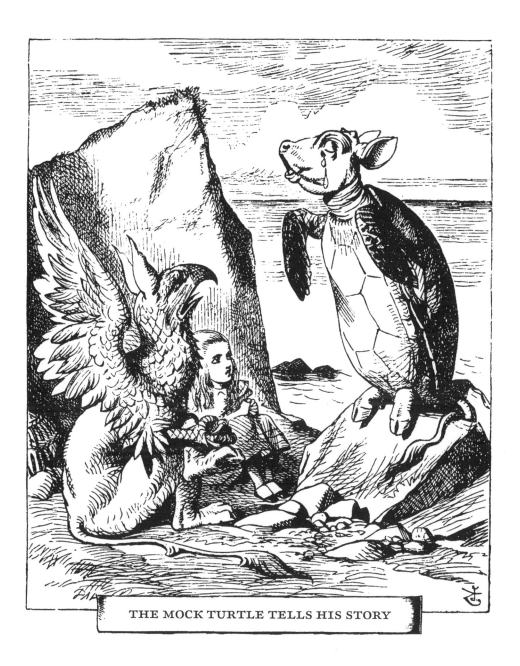

THE MOCK TURTLE TELLS HIS STORY

*"T*his here young lady," said the Gryphon,
"she wants for to know your history, she do."

"I'll tell it her," said the Mock Turtle in a deep,
hollow tone: "sit down, both of you, and don't speak
a word till I've finished."

So they sat down, and nobody spoke for some minutes.
Alice thought to herself, "I don't see how he can *ever* finish,
if he doesn't begin." But she waited patiently.

"Once," said the Mock Turtle at last, with a deep sigh,
"I was a real Turtle."

Alice's Adventures in Wonderland

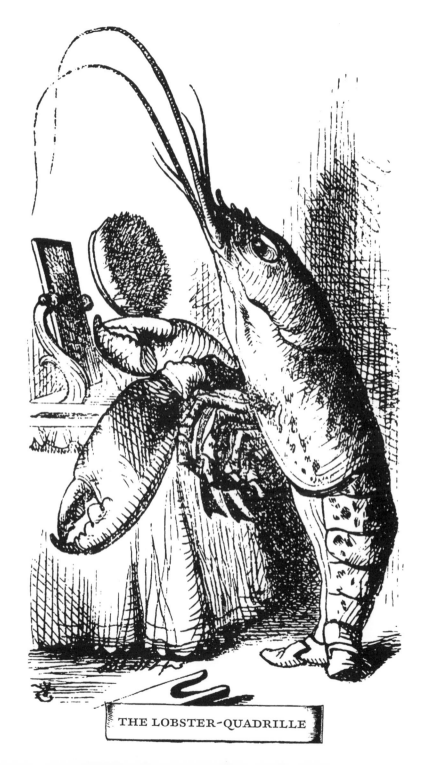

THE LOBSTER-QUADRILLE

" *'T* is the voice of the Lobster; I heard him declare,
'You have baked me too brown, I must sugar my hair.'
As a duck with its eyelids, so he with his nose
Trims his belt and his buttons, and turns out his toes.
When the sands are all dry, he is gay as a lark,
And will talk in contemptuous tones of the Shark:
But, when the tide rises and sharks are around,
His voice has a timid and tremulous sound."

Alice's Adventures in Wonderland

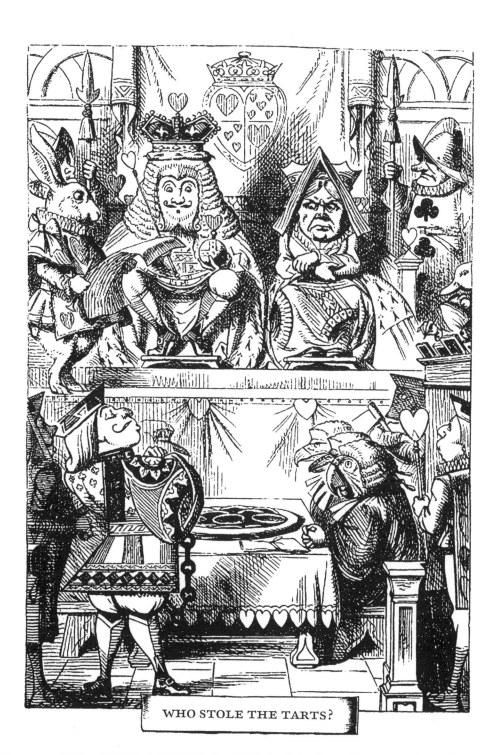

WHO STOLE THE TARTS?

*T*he King and Queen of Hearts were seated on their throne
when they arrived, with a great crowd assembled about them—
all sorts of little birds and beasts, as well as the whole pack of
cards: the Knave was standing before them, in chains, with
a soldier on each side to guard him; and near the King was
the White Rabbit, with a trumpet in one hand, and a scroll of
parchment in the other. In the very middle of the court was a
table, with a large dish of tarts upon it.

Alice's Adventures in Wonderland

Off with their heads!

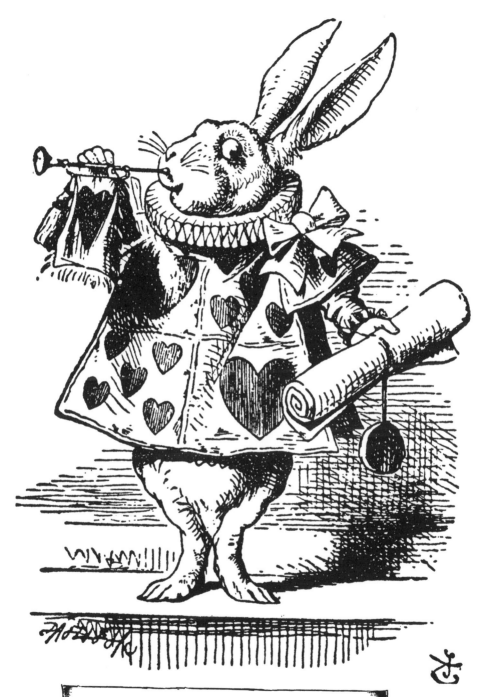

THE WHITE RABBIT READS THE CHARGES

*O*n this the White Rabbit blew three blasts on the trumpet, and then unrolled the parchment scroll, and read as follows:—

"The Queen of Hearts, she made some tarts,
All on a summer day:
The Knave of Hearts, he stole those tarts,
And took them quite away!"

Alice's Adventures in Wonderland

THE MAD HATTER TESTIFIES

*T*he first witness was the Hatter. He came in with a teacup in one hand and a piece of bread-and-butter in the other. "I beg pardon, your Majesty," he began, "for bringing these in; but I hadn't quite finished my tea when I was sent for."

Alice's Adventures in Wonderland

Begin at the beginning and go on till you come to the end: then stop.

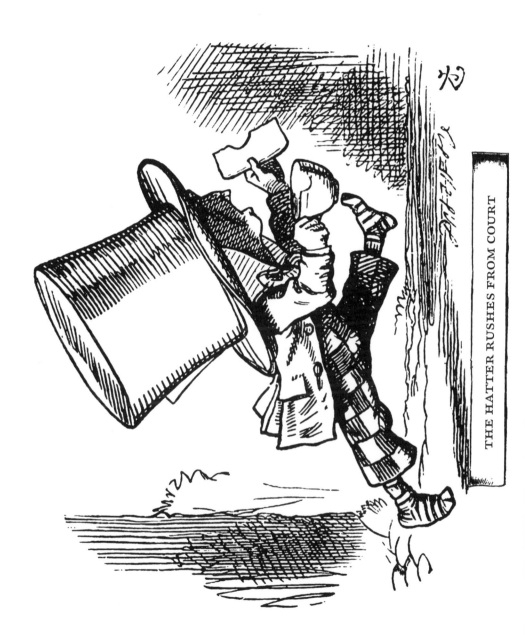

THE HATTER RUSHES FROM COURT

"I'd rather finish my tea," said the Hatter, with an anxious look at the Queen, who was reading the list of singers.

"You may go," said the King, and the Hatter hurriedly left the court, without even waiting to put his shoes on.

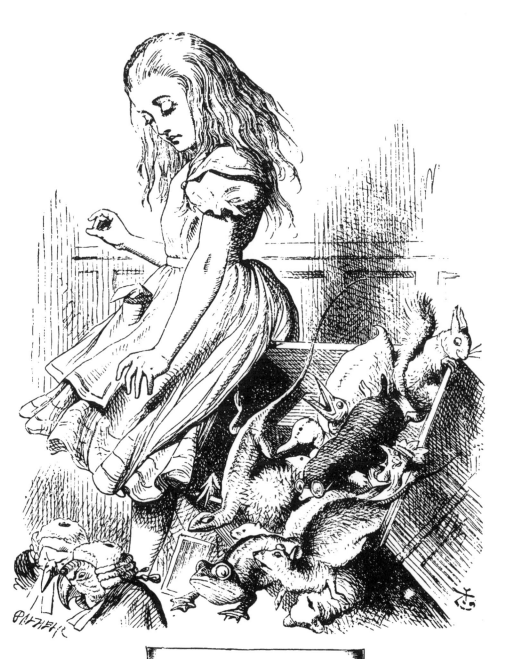

ALICE UPSETS THE JURY

"*H*ere!" cried Alice, quite forgetting in the flurry of the moment how large she had grown in the last few minutes, and she jumped up in such a hurry that she tipped over the jury-box with the edge of her skirt, upsetting all the jurymen on to the heads of the crowd below, and there they lay sprawling about, reminding her very much of a globe of goldfish she had accidentally upset the week before.

Alice's Adventures in Wonderland

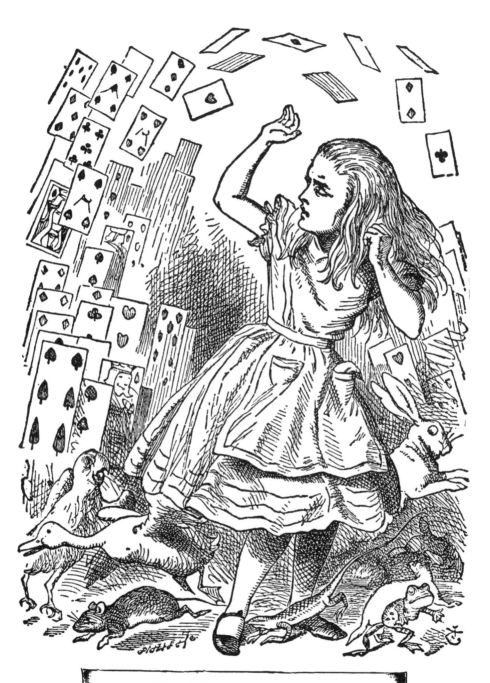

ALICE FENDS OFF THE CARDS

\mathcal{A}t this the whole pack rose up into the air and came flying down upon her: she gave a little scream, half of fright and half of anger, and tried to beat them off, and found herself lying on the bank, with her head in the lap of her sister, who was gently brushing away some dead leaves that had fluttered down from the trees upon her face.

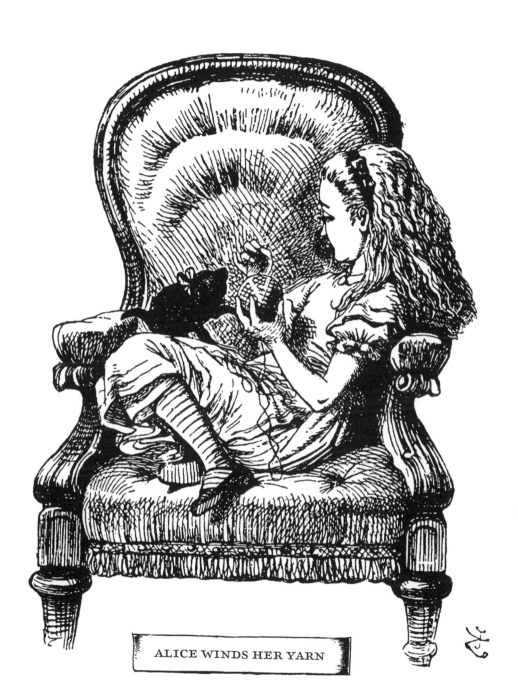

ALICE WINDS HER YARN

*S*he scrambled back into the arm-chair, taking the kitten and the worsted with her, and began winding up the ball again. But she didn't get on very fast, as she was talking all the time, sometimes to the kitten, and sometimes to herself. Kitty sat very demurely on her knee, pretending to watch the progress of the winding, and now and then putting out one paw and gently touching the ball, as if it would be glad to help, if it might.

Through the Looking-Glass, and What Alice Found There

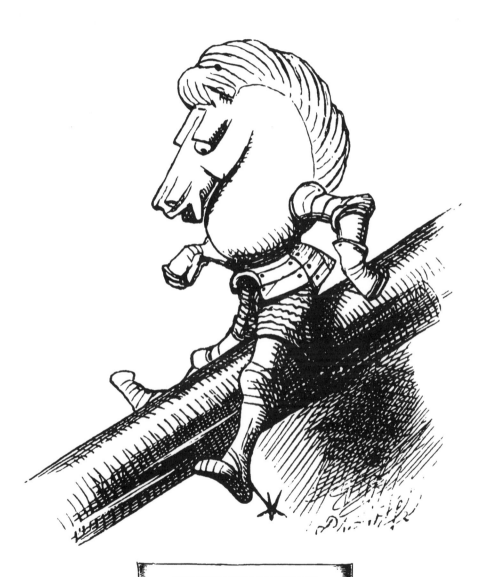

THE WHITE KNIGHT

*T*he poor King looked puzzled and unhappy, and struggled
with the pencil for some time without saying anything;
but Alice was too strong for him, and at last he panted out,
"My dear! I really *must* get a thinner pencil.
I can't manage this one a bit; it writes all manner
of things what I don't intend—"

"What manner of things?" said the Queen, looking over
the book (in which Alice had put "*The White Knight
is sliding down the poker. He balances very badly*").

Through the Looking-Glass, and What Alice Found There

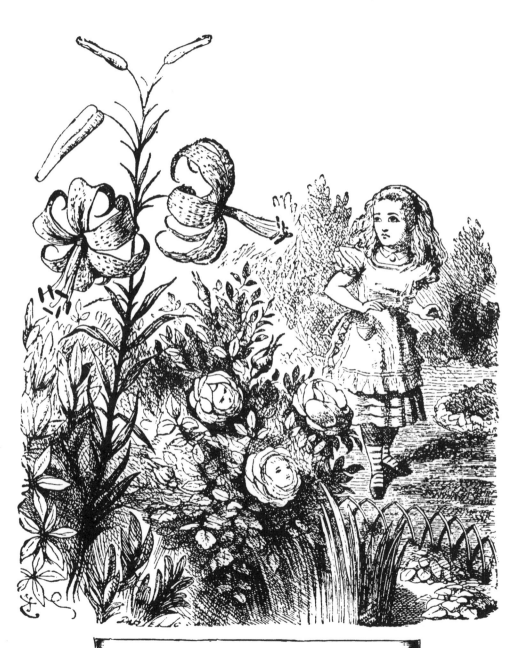

THE GARDEN OF LIVE FLOWERS

*T*his time she came upon a large flower-bed, with a border of daisies, and a willow-tree growing in the middle.

"O Tiger-lily!" said Alice, addressing herself to one that was waving gracefully about in the wind, "I *wish* you could talk!"

"We *can* talk," said the Tiger-lily: "when there's anybody worth talking to."

Alice was so astonished that she could not speak for a minute: it quite seemed to take her breath away.

Through the Looking-Glass, and What Alice Found There

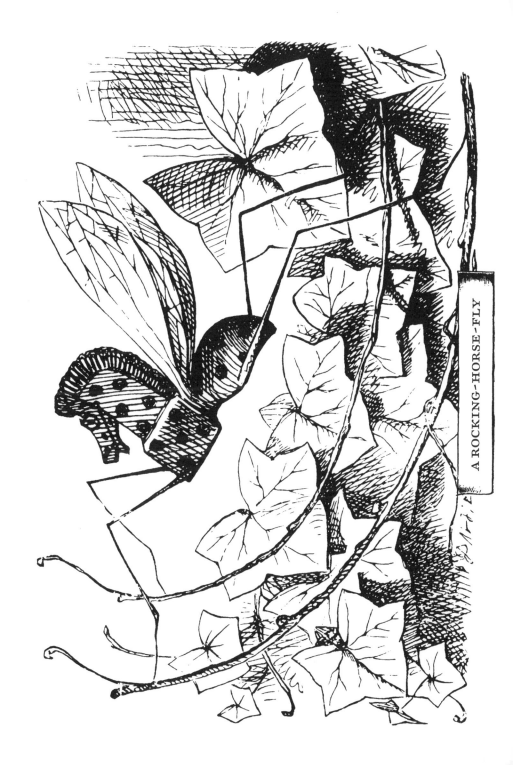

A ROCKING-HORSE-FLY

"All right," said the Gnat: "half way up that bush, you'll see a Rocking-horse-fly, if you look. It's made entirely of wood, and gets about by swinging itself from branch to branch."

"What does it live on?" Alice asked, with great curiosity.

"Sap and sawdust," said the Gnat.

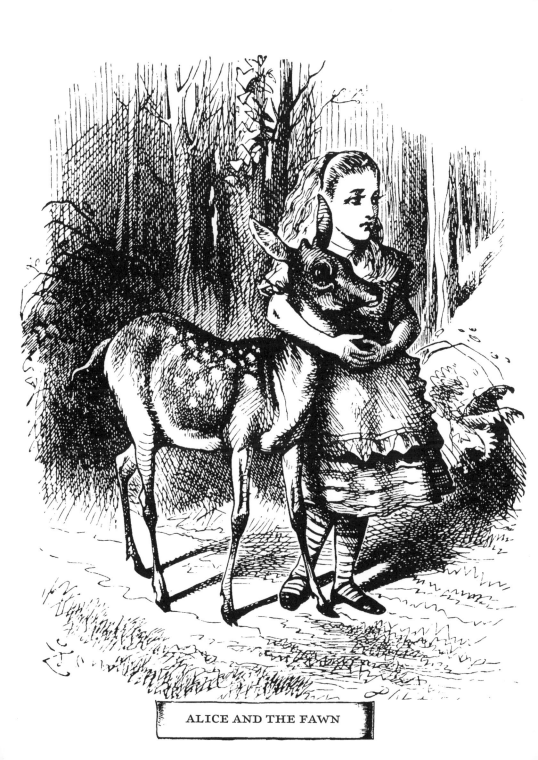

ALICE AND THE FAWN

*S*o they walked on together through the wood, Alice with her arms clasped lovingly round the soft neck of the Fawn, till they came out into another open field, and here the Fawn gave a sudden bound into the air, and shook itself free from Alice's arms. "I'm a Fawn!" it cried out in a voice of delight, "and dear me! you're a human child!" A sudden look of alarm came into its beautiful brown eyes, and in another moment it had darted away at full speed.

Through the Looking-Glass, and What Alice Found There

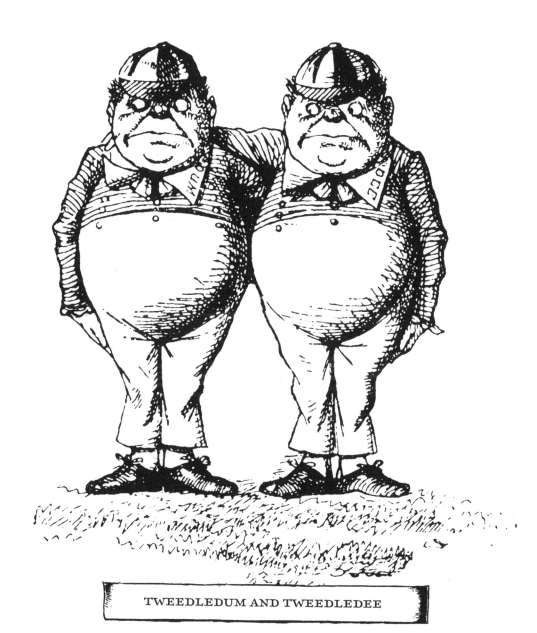

TWEEDLEDUM AND TWEEDLEDEE

*T*hey were standing under a tree, each with an arm
round the other's neck, and Alice knew which was which
in a moment because one of them had "DUM"
embroidered on his collar, and the other "DEE."
"I suppose they've each got 'TWEEDLE' round at
the back of the collar," she said to herself.

Through the Looking-Glass, and What Alice Found There

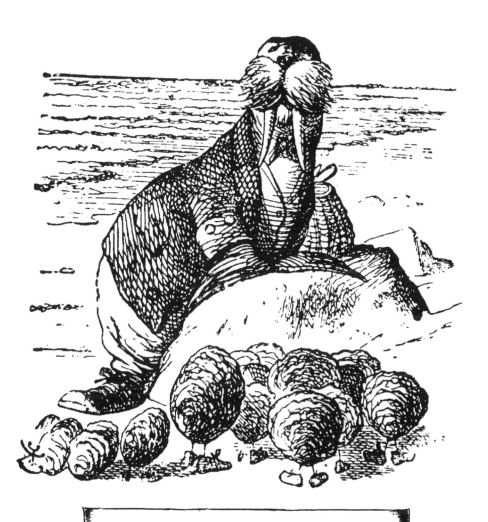

THE WALRUS AND THE OYSTERS

"*T*he Walrus and the Carpenter
Walked on a mile or so,
And then they rested on a rock
Conveniently low:
And all the little Oysters stood
And waited in a row."

Through the Looking-Glass, and What Alice Found There

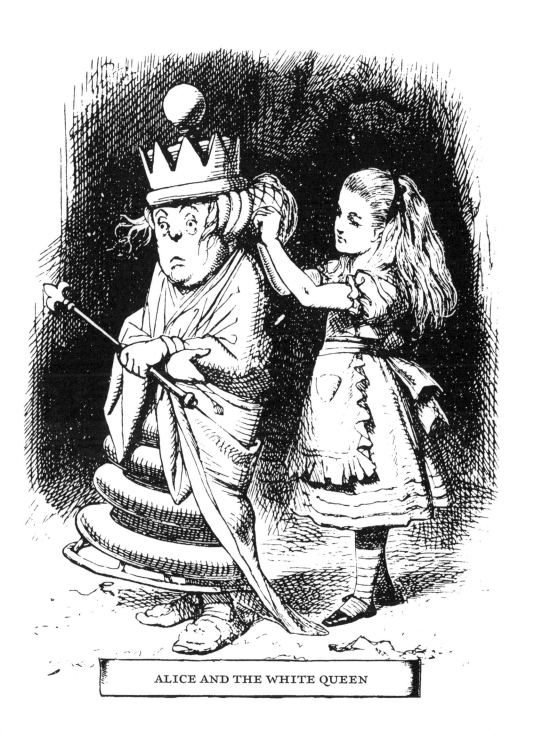

ALICE AND THE WHITE QUEEN

*I*t would have been all the better, as it seemed to Alice, if she had got some one else to dress her, she was so dreadfully untidy. "Every single thing's crooked," Alice thought to herself, "and she's all over pins!—may I put your shawl straight for you?" she added aloud.

"I don't know what's the matter with it!" the Queen said, in a melancholy voice. "It's out of temper, I think. I've pinned it here and I've pinned it there, but there's no pleasing it!"

Sometimes I've believed as many as six impossible things before breakfast.

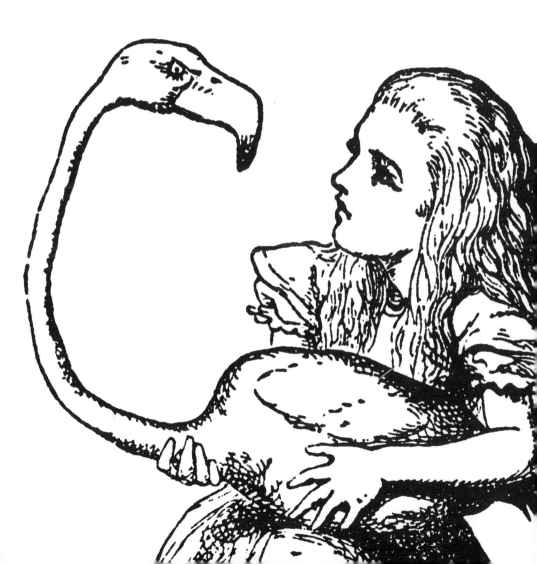

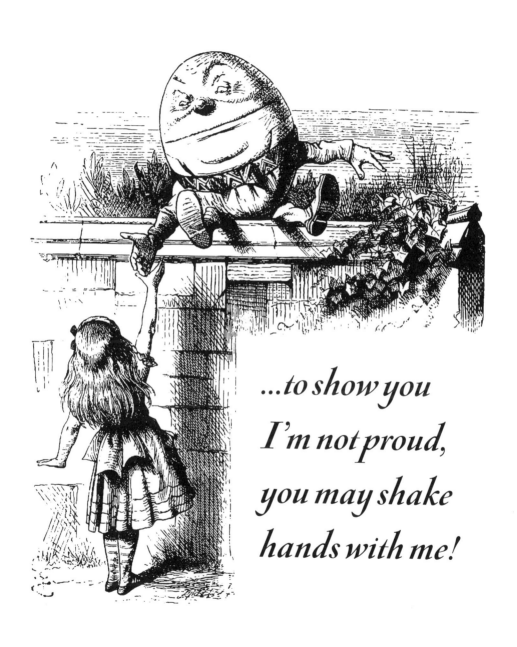

*...to show you
I'm not proud,
you may shake
hands with me!*

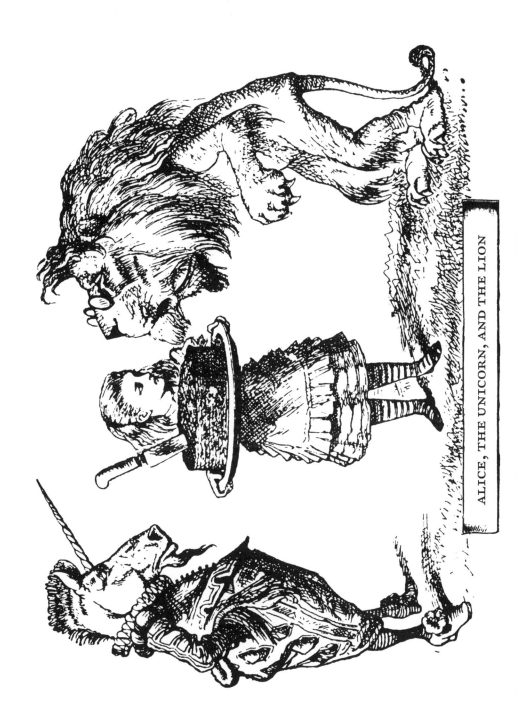

ALICE, THE UNICORN, AND THE LION

*T*he Lion looked at Alice wearily. "Are you animal—vegetable—or mineral?" he said, yawning at every other word.

"It's a fabulous monster!" the Unicorn cried out, before Alice could reply.

"Then hand round the plum-cake, Monster," the Lion said, lying down and putting his chin on his paws.

It's always tea-time.

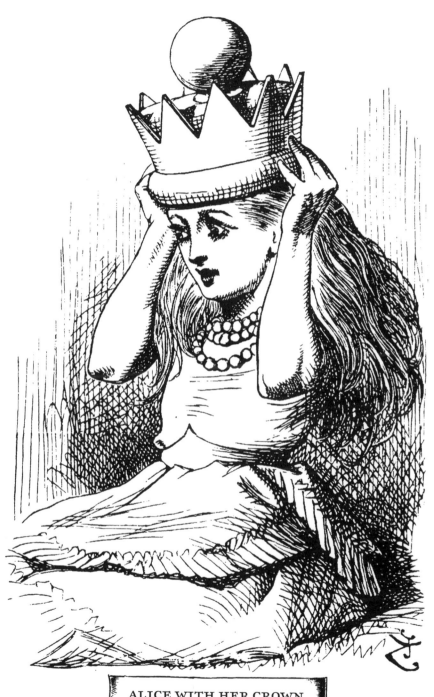

ALICE WITH HER CROWN

"*A*nd what *is* this on my head?" she exclaimed in a tone of dismay, as she put her hands up to something very heavy, and fitted tight all round her head.

"But how *can* it have got there without my knowing it?" she said to herself, as she lifted it off, and set it on her lap to make out what it could possibly be.

It was a golden crown.

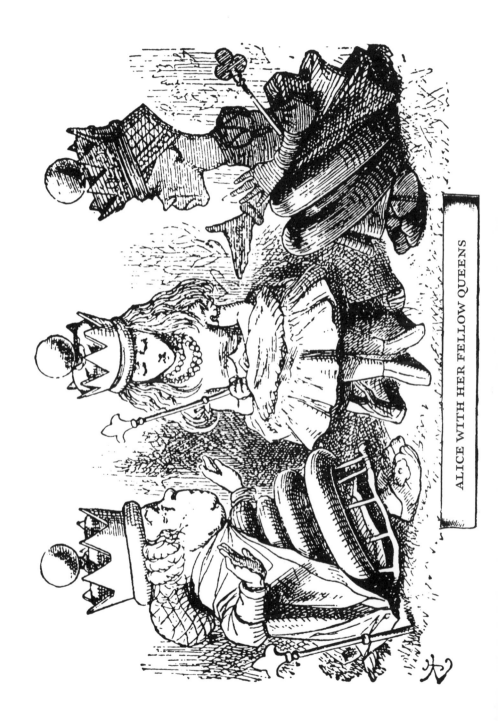

ALICE WITH HER FELLOW QUEENS

Everything was happening so oddly that she didn't feel a bit surprised at finding the Red Queen and the White Queen sitting close to her, one on each side: she would have liked very much to ask them how she came there, but she feared it would not be quite civil. However, there would be no harm, she thought, in asking if the game was over.

Through the Looking-Glass, and What Alice Found There

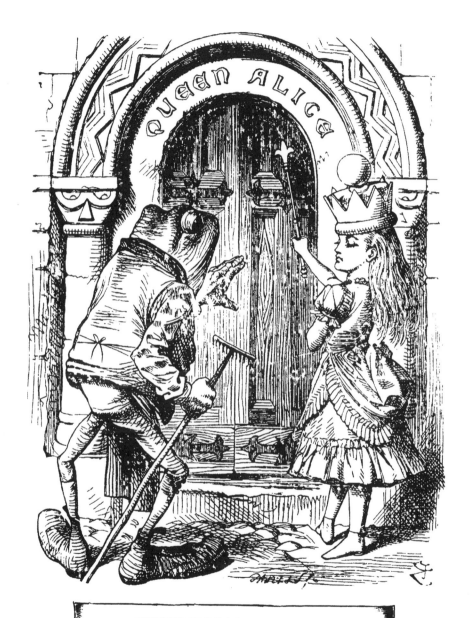

QUEEN ALICE AND THE FROG

A lice knocked and rang in vain for a long time, but at last,
a very old Frog, who was sitting under a tree, got up and
hobbled slowly towards her: he was dressed in bright yellow,
and had enormous boots on.

Through the Looking-Glass, and What Alice Found There

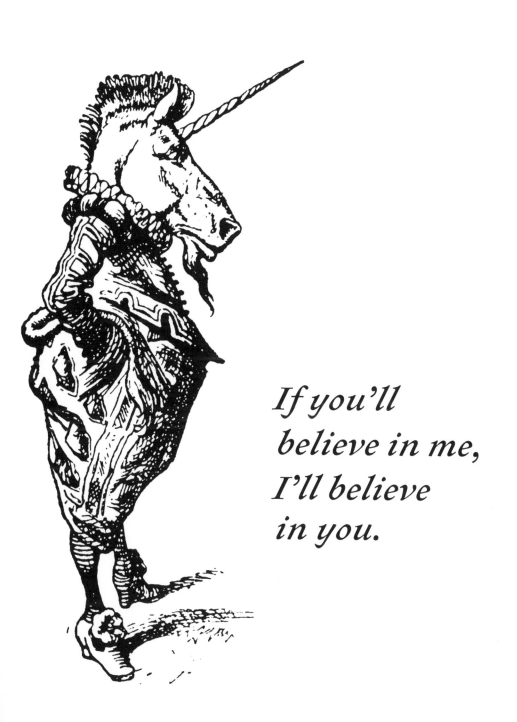

*If you'll
believe in me,
I'll believe
in you.*